CW00693000

FOR
YOU

Published by Familius LLC, www.familius.com
PO Box 1249, Reedley, CA 93654

Familius books are available at special discounts for bulk purchases,
whether for sales promotions or for family or corporate use.
For more information, email orders@familius.com.

Library of Congress Control Number: 2022930972

Print ISBN 9781641706599

Printed in China

Edited by Lacey Wulf
Cover art and book design by Jessica Sharp

10 9 8 7 6 5 4 3 2 1

First Edition

FOR
YOU

100+ Positive Reminders for when you Need Them Most

Jess Rachel Sharp

Introduction

I started to create these reminders when I really needed to hear and absorb the words myself. Writing them down offered me a way of holding space for my emotions, which I found to be such a soothing outlet. After sharing them to my Instagram, I realized that I wasn't alone in what I felt and that they resonated with others too.

I hope this book offers you some reassurance in knowing that you are not alone. I hope it reminds you that it's okay to feel. It's okay to sit and process it all. Most of all, I hope this book brings comfort when you need it most. Much love,

Jess X

About This Book

Life can sometimes be challenging, and navigating its various ups and downs can be difficult. This book has been designed to offer comforting words of support to help you through it all.

Dip into it whenever you need a reassuring reminder. Flick through it when things are beginning to feel a little harder than they should. Share it with a friend when they're struggling. This book aims to remind you that you are never alone in what you feel. That you matter and you deserve to be happy.

keep going,
keep growing

I HOPE YOU ARE OKAY.
I HOPE YOU ARE BEING
GENTLE WITH YOURSELF.
I HOPE YOUR INNER
VOICE IS BEING KIND.
I HOPE YOU ARE PROUD
OF ALL YOU'VE
OVERCOME.

YOUR NEEDS ARE
IMPORTANT.
YOUR WELLNESS
MATTERS.

EVEN on your hardest
days, EVEN when you
are feeling your worst,
you are still deserving
of so much love.

YOU DESERVE GOOD THINGS.
YOU DESERVE TO BE HAPPY.
YOU DESERVE TO FEEL LOVED,
WHOLE, AND WANTED JUST
AS YOU ARE.

IT
HURTS
BUT IT
WILL
HEAL.

meet yourself
where you are

BRAVERY IS RELATIVE
TO YOUR OWN
PERSONAL STRUGGLES.
NEVER LET ANYONE
MAKE YOU FEEL LIKE
YOUR BRAVE ISN'T
WORTH
CELEBRATING .

YOU DO <u>NOT</u>
HAVE TO WORK OUT
ALL THE ANSWERS
RIGHT NOW.
IT'S OKAY TO TAKE
YOUR TIME. IT'S
OKAY TO JUST BE.
XX

YOU
MATTER

even on the days when
you feel like you don't

THERE IS

POWER

IN YOUR

VULNERABILITY

IT'S OKAY
TO JUST LET
YOURSELF
FEEL IT FOR
A WHILE.

YOU ARE NOT A FAILURE.
YOU ARE NOT LETTING
ANYBODY DOWN. YOUR
STRENGTH IS ASTOUNDING,
AND I CANNOT BEGIN TO
TELL YOU HOW SPECIAL
AND WONDERFUL YOU ARE.

IT IS NOT SELFISH
TO LOVE YOURSELF,
TO TAKE CARE
OF YOURSELF,
TO MAKE YOUR OWN
HAPPINESS A PRIORITY —
IT'S NECESSARY.

KEEP BEING
BRAVE

don't let people rush
you. take your time and
go at your own pace.

you are doing so much better

than you think you are

THEIR
SUCCESS IS
<u>NOT</u> YOUR
FAILURE

DO NOT ALLOW OTHER PEOPLE'S OPINIONS OF YOU ALTER HOW YOU FEEL ABOUT YOURSELF. NOT EVERYONE WILL LIKE YOU — AND THAT'S OKAY.

KEEP BEING KIND. KEEP TRYING.
KEEP LISTENING. KEEP LOVING.
BECAUSE SOMETIMES THE
SMALLEST RIPPLES
TOGETHER CAN MAKE
A WAVE.

YOUR THOUGHTS
ARE NOT
FACTS.

EVEN ON THE DAYS WHEN YOU FEEL LIKE A
FRAUD. THE DAYS WHEN YOU'RE WORRIED ABOUT
MESSING EVERYTHING UP. WHEN YOU FEEL LIKE
YOU DON'T KNOW ENOUGH OR HAVEN'T DONE
ENOUGH. EVEN ON THE DAYS WHEN YOU JUST
CAN'T CONNECT WITH WHAT YOU LOVE TO DO.
YOU ARE STILL DOING SO MUCH BETTER THAN
YOU THINK YOU ARE. THE SUCCESS YOU HOLD
IS EARNED AND ABSOLUTELY DESERVED.

BREATHE

it will be okay

THERE DOESN'T
ALWAYS NEED TO
BE A REASON.
SOMETIMES
FEELINGS JUST
ARE.

EVEN THOUGH YOU FEEL ALONE,
I PROMISE THAT YOU'RE NOT.

SOME GENTLE REMINDERS

YOU MATTER, EVEN ON THE DAYS
WHEN YOU FEEL LIKE YOU DON'T.

YOU HAVE GOTTEN THROUGH EVERYTHING
UP TO THIS VERY MOMENT, EVEN WHEN
YOU FELT LIKE YOU WOULDN'T.

YOU HAVE MORE STRENGTH AND
RESILIENCE THAN YOU REALIZE, BUT
THAT DOESN'T MEAN YOU HAVE TO FACE
EVERYTHING ALL ON YOUR OWN.

YOU DESERVE TO GET HELP AND SEEK
SUPPORT. YOU DESERVE TO GET BETTER.

YOU CAN DO IT.
EVEN THOUGH IT
FEELS HARD.
EVEN THOUGH IT
SEEMS IMPOSSIBLE AT
THIS VERY MOMENT.
YOU CAN DO IT.
YOU CAN.
YOU CAN.

THINGS TO REMEMBER:

1. YOU ARE NOT FAILING.

2. YOU ARE NOT A BURDEN.

3. YOU DESERVE GOOD THINGS.

it's okay to not
do it all

WHEN IT FEELS
MORE DIFFICULT,
BE MORE GENTLE

YOU DO NOT
ALWAYS HAVE
TO INVITE
IT IN.

IT'S OKAY TO
LET GO.
IT'S OKAY TO
MOVE ON.

keep trying

TO DO TODAY:

- FORGIVE YOURSELF
- FORGIVE YOURSELF
- FORGIVE YOURSELF

YOU ARE LOVED.
YOU ARE NEEDED.
YOU MAKE THIS WORLD
SO MUCH MORE WONDERFUL
JUST BY BEING IN IT.

Listen to what y<u>ou</u> need

ASKING FOR
HELP DOES NOT
MAKE YOU
ANY LESS
INDEPENDENT.

YOU WILL
FIND THE
LIGHT
AGAIN.

YOU ARE WORTHY OF
WONDERFUL THINGS.
YOU DESERVE TO
BE HAPPY.

YOU
DESERVE
GOOD
THINGS

YOUR SPEED DOES
<u>NOT</u> MATTER —
PROGRESS IS
PROGRESS ♡

IT'S OKAY
TO SOMETIMES
NEED PEOPLE. IT'S
OKAY TO ASK FOR
THEIR HELP &
SUPPORT.

IT'S OKAY
TO BE
SENSITIVE

IT'S OKAY TO
FIND CHANGE
DIFFICULT,
EVEN IF IT IS
POSITIVE.

no matter how small,
kindness makes a difference.

TINY

STEPS STILL

TAKE

YOU

THERE

DO MORE
THINGS THAT
FILL YOU UP

There is strength
in being gentle

YOU CANNOT
BE RESPONSIBLE
FOR OTHER PEOPLE'S

HAPPINESS

YOU HAVE <u>SURVIVED</u>

THIS BEFORE.

YOU <u>WILL</u> SURVIVE

IT AGAIN.

you do not have to be
accessible to everybody
all of the time.

YOU DESERVE TO
MAKE DECISIONS BASED
AROUND YOUR OWN
HAPPINESS

you're
like
SUNSHINE

I KNOW AT
TIMES IT FEELS
BIGGER
THAN YOU,
BUT I PROMISE
THAT IT ISN'T.

YOU
HAVE MORE
COURAGE THAN
YOU GIVE
YOURSELF CREDIT
FOR.

You will feel joy
again. It may not
feel like it right now,
but it is always
there, waiting
patiently to be
found.

YOUR WORTH IS NOT

DETERMINED BY OTHERS

OR THEIR ACTIONS.

THIS RESTLESSNESS.
THIS UNCERTAINTY.
THIS ACHING.
IT WILL NOT BE THIS
LOUD FOREVER.

IT'S OKAY IF THINGS THAT
ONCE FELT EASY NOW FEEL
MORE DIFFICULT. YOU ARE
ALLOWED TO CHANGE YOUR
MIND AND ALTER PLANS IF IT
MEANS PROTECTING YOUR OWN
WELL-BEING. IT DOESN'T MAKE
YOU USELESS, AND IT MOST
DEFINITELY DOES NOT
MAKE YOU A FAILURE.

ALLOW YOURSELF

TO BE WHO YOU ARE, AS YOU ARE,

IN THIS VERY MOMENT.

YOU ARE
MORE RESILIENT
THAN YOU THINK
AND SO MUCH
STRONGER THAN
YOU FEEL

YOUR
BRIGHTER DAYS
ARE COMING

You have gotten through
everything up to this
moment. That's how
resilient you are.
That's how amazingly
strong you are.
Always remember that.

IT'S OKAY
IF YOU FEEL IT...
AND STILL FEEL IT...
AND STILL FEEL IT...
SOME THINGS JUST
TAKE TIME.

ALL THIS LOVE YOU
GIVE TO OTHERS,
IT'S TIME TO TURN
SOME OF IT INWARD.

YOU CAN'T PLEASE
EVERYONE ALL
THE TIME — AND
THAT'S OKAY.

TRY NOT TO
LET YOUR FEARS
SHOUT LOUDER
THAN YOUR
SELF-BELIEF

YOU ARE

GOOD ENOUGH

YOU ARE ALLOWED
TO ASK FOR HELP.
YOU ARE ALLOWED TO
SEEK SUPPORT.
IT DOES <u>NOT</u> MAKE YOU
A BURDEN.
IT DOES <u>NOT</u> MAKE YOU
A FAILURE.

YOUR BEST WILL ALWAYS DIFFER
AND LOOK DIFFERENT FROM DAY
TO DAY. WHATEVER YOUR BEST
LOOKS LIKE AT THE MOMENT IS
OKAY AND ABSOLUTELY MORE
THAN ENOUGH.

THERE WILL BE DAYS WHEN YOU'LL FEEL UNSTOPPABLE, LIKE YOU CAN ACHIEVE ANYTHING, AND DAYS WHEN DOING ANYTHING AT ALL FEELS LIKE THE HARDEST THING IN THE WORLD. YOU ARE NO LESS BRILLIANT ON EITHER DAY, AND YOU ARE CERTAINLY NO LESS WORTHY.

A MINI PEP TALK:

YOU CAN DO IT. EVEN
THOUGH SOMETIMES
YOU DOUBT YOURSELF.
EVEN THOUGH AT TIMES
IT CAN FEEL SO
OVERWHELMING. DO NOT
WORRY. BREATHE. TRUST
YOURSELF. KNOW THAT YOU
ARE CAPABLE & YOU ARE
GOING TO ABSOLUTELY
SMASH IT!

You have
a nice
heart

it's okay to feel sad

YOU ARE SO
DESERVING OF LOVE,
EVEN WHEN YOU
FEEL UNLOVABLE.

YOU MATTER.

YOU ARE NOT A FAILURE.

YOU ARE NOT A BURDEN.

YOU ARE WORTHY OF

SO MUCH LOVE.

IT'S OKAY TO FEEL MORE THAN ONE FEELING AT THE SAME TIME.

IT'S COOL IF YOU
NEED TO CRY

EVERYTHING WILL
BE OKAY... AND IF IT
ISN'T, YOU <u>WILL</u> GET
THROUGH IT AND
EVERYTHING WILL
BE OKAY. ♡

TRY NOT TO
PUT SO MUCH
PRESSURE
ON YOURSELF

YOUR FUTURE IS
FILLED WITH SO MUCH
POTENTIAL AND SO MANY
WONDERFUL THINGS.

SOME DAYS YOU WON'T FEEL VERY
CAPABLE AND YOU WON'T FEEL VERY
RESILIENT, BUT THAT'S OKAY. WE ALL
HAVE THOSE DAYS. WE ARE ALL HUMAN.
DON'T PUSH YOURSELF TOO HARD OR
BERATE YOURSELF FOR IT. LET THOSE
DAYS COME, AND LET THOSE DAYS GO,
AND JUST REMEMBER — EVEN THOUGH
YOU FEEL THAT WAY, IT DOESN'T
MAKE ANY OF IT TRUE.

THERE IS STILL TIME FOR
FRESH STARTS, FOR HEALING,
FOR NEW LOVE & FRIENDSHIPS.
FOR LEARNING, GROWING, BECOMING.
THERE IS STILL TIME.

CHANGE
is scary but
you will
manage

It might not feel like it at the moment, but one day you will look back on all that has happened, all that you've gotten through, all you've become, and realize that growth was happening all along.

IT'S OKAY TO

ALTER PLANS.

YOU ARE ALLOWED

TO CHANGE

YOUR MIND.

YOUR HEART WILL REMEMBER

THE WAY OUT OF THIS

THREE IMPORTANT REMINDERS...

1. YOU MATTER.

2. YOU ARE LOVED.

3. EVERYTHING WILL BE OKAY.

TAKE A MOMENT TO
STOP AND CELEBRATE
HOW FAR YOU'VE ALREADY
COME. SAVOR IT. BE
PROUD. YOU HAVE DONE
AMAZINGLY WELL, AND
YOU DESERVE TO PAUSE
AND JUST FEEL GOOD
ABOUT IT.

the
WORRIES
WILL NOT
ALWAYS
WIN.

THIS
FEELING IS
UNCOMFORTABLE,
BUT IT <u>WILL</u>
PASS.

your empathy
helps others feel
less alone

NOURISH THE GOOD THOUGHTS & LET THEM GROW

TRUST
YOURSELF

YOU ARE SAFE.

YOU ARE LOVED.

IT WILL BE OKAY.

You deserve to
be _HAPPY_; Stop
convincing Yourself
that You don't —
Because You do, You
do, _YOU DO_.

you do not have to
be anything more
than the whole,
beautiful being that
you are.

YOU ARE ALLOWED TO PROTECT YOUR PEACE.
YOU ARE ALLOWED TO PROTECT YOUR PEACE.
YOU ARE ALLOWED TO PROTECT YOUR PEACE.
YOU ARE ALLOWED TO PROTECT YOUR PEACE.
YOU ARE ALLOWED TO PROTECT YOUR PEACE.
YOU ARE ALLOWED TO PROTECT YOUR PEACE.
YOU ARE ALLOWED TO PROTECT YOUR PEACE.
YOU ARE ALLOWED TO PROTECT YOUR PEACE.
YOU ARE ALLOWED TO PROTECT YOUR PEACE.
YOU ARE ALLOWED TO PROTECT YOUR PEACE.
YOU ARE ALLOWED TO PROTECT YOUR PEACE.
YOU ARE ALLOWED TO PROTECT YOUR PEACE.
YOU ARE ALLOWED TO PROTECT YOUR PEACE.
YOU ARE ALLOWED TO PROTECT YOUR PEACE.
YOU ARE ALLOWED TO PROTECT YOUR PEACE.
YOU ARE ALLOWED TO PROTECT YOUR PEACE.

ALL THAT COMPASSION YOU SHOW TO

OTHERS, REMEMBER THAT YOU ARE MORE

THAN WORTHY OF IT TOO.

YOU ARE MORE THAN GOOD.
YOU ARE MORE THAN YOUR
WORST THOUGHTS.
YOU ARE DESERVING OF THE
LOVELIEST THINGS.
YOU ARE. YOU ARE. YOU ARE.

THIS GROWTH MAY
NOT BE EASY, BUT
JUST KEEP TRUSTING
IN IT. JUST KEEP
BREATHING THROUGH
IT. IT IS GUIDING
YOU SOMEWHERE WORTH
GOING. I PROMISE.

I HOPE THAT EVEN ON THE
HARDEST OF DAYS,
COMFORT FINDS YOU.
I HOPE YOU CAN ALLOW
YOURSELF TO TRUST, THAT EVEN
WHEN IT FEELS SO FAR AWAY,
JOY WILL ALWAYS REMEMBER
THE ROUTE TO YOUR DOOR.
AND I HOPE, HARD AS I KNOW
IT IS, THAT YOU CAN BE
GENTLE WITH YOURSELF
IN THE WAITING.

not
everything
has to be
perfect to
be good

YOUR BEST, NO
MATTER WHAT THAT
LOOKS LIKE TODAY,
IS ENOUGH.
YOU ARE ALWAYS
ENOUGH.

LOOK AT YOU.

LIVING. BREATHING.

SURVIVING ALL OF THIS.

If it's all
becoming a bit
too much, it's
okay to take
some time away

THERE WILL BE GOOD DAYS, AND THERE WILL BE BAD DAYS. DON'T LET THE BAD DAYS MAKE YOU THINK YOU ARE DOING ANY LESS BRILLIANTLY THAN YOU ARE.

Acknowledgements

To Pete, for your constant, unwavering support
and for always believing in me, even when I
struggle to believe in myself.

To Florence, my darling sunshine girl.
I hope you always know how special and loved you are.

To my family, for being there without fail and helping me
through all my ups and downs.

To Sarah, for helping me find the light when all I could see was
darkness. The content of this book would not exist if it
wasn't for you.

About the Author

Jess Rachel Sharp is a designer, illustrator, writer, and

mental health advocate based in Yorkshire, UK. Find

more of Jess's work on her Instagram @jessrachelsharp

or on her website www.jessrachelsharp.com

About Familius

Visit Our Website: www.familius.com

Familius is a global trade publishing company that publishes books and other content to help families be happy. We believe that the family is the fundamental unit of society and that happy families are the foundation of a happy life. We recognize that every family looks different, and we passionately believe in helping all families find greater joy. To that end, we publish books for children and adults that invite families to live the Familius Ten Habits of Happy Family Life: *love together, play together, learn together, work together, talk together, heal together, read together, eat together, laugh together,* and *give together.*

Founded in 2012, Familius is located in Sanger, California.

Connect

Facebook: www.facebook.com/familiustalk

Twitter: @familiustalk, @paterfamilius1

Pinterest: www.pinterest.com/familius

Instagram: @familiustalk

"The most important work you ever do will be within the walls of your own home."